A KRAMPUS CAROL
CREATE-YOUR-OWN-ADVENTURE COLORING BOOK

ART, STORY, AND SONG BY
LAUREN ONÇA O'LEARY

COVER AND LAYOUT BY STEVEN WARRICK

EDITING BY DANA JONES

MUSIC SCORE BY AL COFRIN

WWW.HARDESTWORKINGWOMANINSHOWBUSINESS.COM

A KRAMPUS CAROL
CREATE-YOUR-OWN-ADVENTURE COLORING BOOK

Preface

Plates:

I. The Classic Krampus

II. An Alpine Village Holiday

III. Krampus & Friends in the City

IV. The Eternal Sacred Hart

V. Better Than A Sleigh!

VI. It's Bigger on the Inside

VII. The Horned God is Everywhere

VIII. Perchta in the Winterscape

IX. A Very Hot Place

X. A Very Krampus Holiday… in Spain

XI. A Creepy Cutie Krampus Doll

XII. A Krampus Carol sheet music

XIII. Krampus Greetings

PREFACE

Who is Krampus, you say? He's the charming Alpine Anti-Hero of the winter holidays. He's the horned Wild Man who accompanies good St. Nick on his rounds, and instead of giving out presents, he carries a switch and carts off the naughty in his magic sack. (It's bigger on the inside, of course.) He is the cure for everything sickly-sweet and saccharine about Christmas, and because of that, his fans are now increasing worldwide. He's cheeky, hunky, and wicked for the Good Cause of Being Bad. We need him.

As Oscar Wilde said of ancient Pan, "Oh goat-foot God of Arcady...This modern world hath need of thee."

So, what is this book, then?

Firstly, this book is a folky coloring book on the delightful theme of Krampus, the increasingly global Alpine folk anti-hero of the holidays season. And coloring is what everyone with TOO MUCH TO DO is doing nowadays to chill out. And nobody is more chill than a snow monster! These images are rendered in Scratchbord, a new medium for me, which gives it a slightly medieval, eerie, dark-and-tingley quality. The art is family friendly, totally PG, and with lots of textures for the avid colorist. It floats freely through many ways of viewing Krampus and his cohort, from campy to epic.

Secondly, this is a fun 'Create-Your-Own-Adventure' story, exploring aspects of the Krampus mythos with a tender archetypal bent. He plays 'bad cop' to goodie-two-shoes St. Nick, and allows the ancient character of the Wild Man a toehold in this modern world. The concept of the story is definitely for the Young Adult and Adult set, but again, it's totally PG. The 'Adult' version could be very racy indeed. Do an internet search for vintage images of Krampus, and he's always dipping some tipsy flapper over a velvet couch or dancing the night away with a cigar in hand. My son Zipflash wants you to know that the 'Create-Your-Own-Adventure' part was his idea.

Thirdly, it comes with an appendix of lyrics and sheet music for a zesty original Krampus-tide holiday carol. You'll soon see video on the crowdfunding site of folks rocking out to it! The story makes reference to it, as well.

On a more personal note, making this Krampus art has saved my sanity. I'm a performer and teacher, but the chronic illness of my teenage son has pulled me from the stage and the classroom and into a much more isolated and medicalized life. Making art from the wry, tongue-in-cheek hedonism of Krampus and the myths surrounding him has allowed me to remain creatively ALIVE. I was able to carry on this work in even the most soul-deadening hospitals, dreadful bedside vigils and during the relentless grind that is medical advocacy in the American health care system. (Which does not work perfectly, by the way.) It gave me refuge and succour and satisfaction and fun - may it bring you and yours some joy, all year round.

~Lauren Onça O'Leary

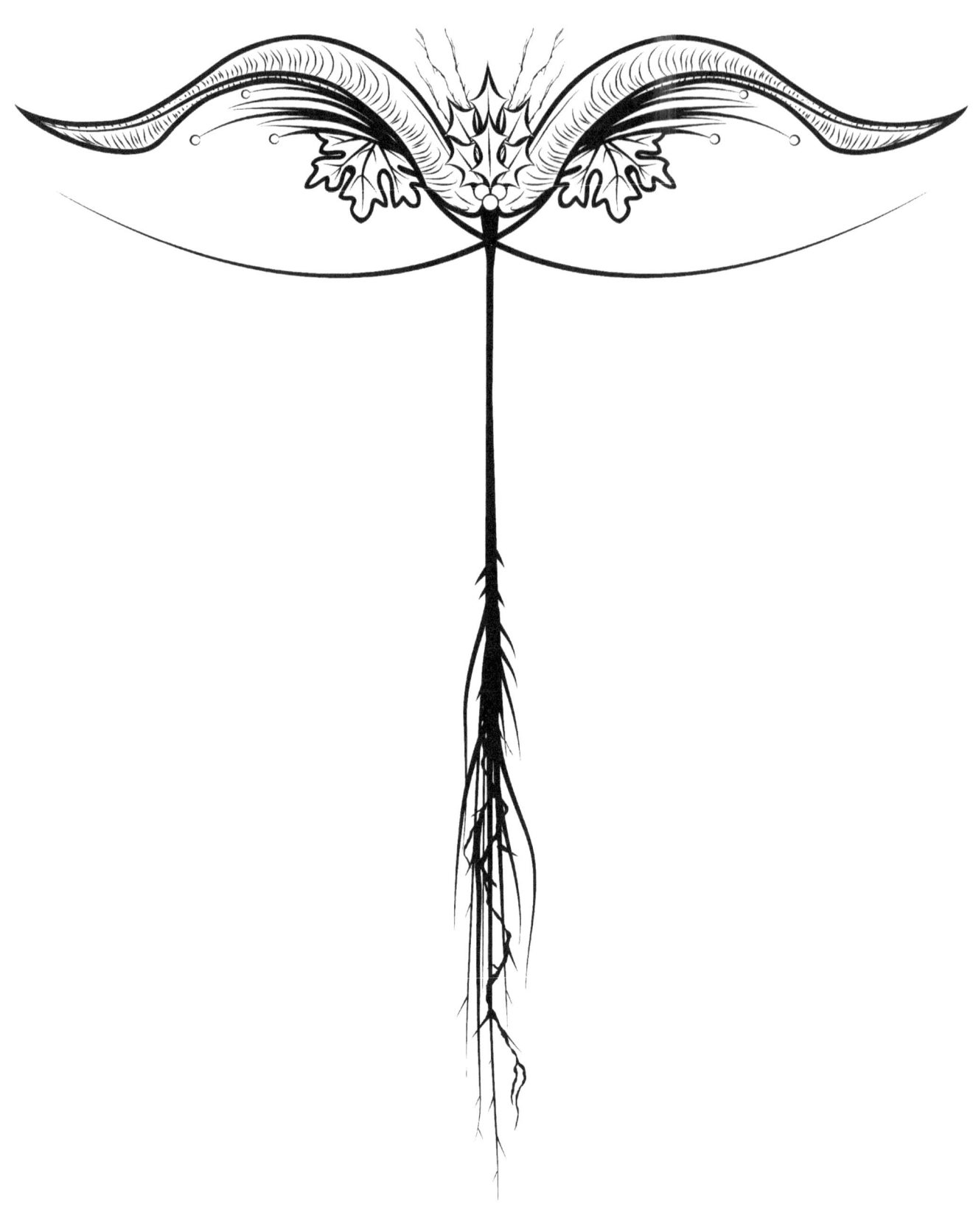

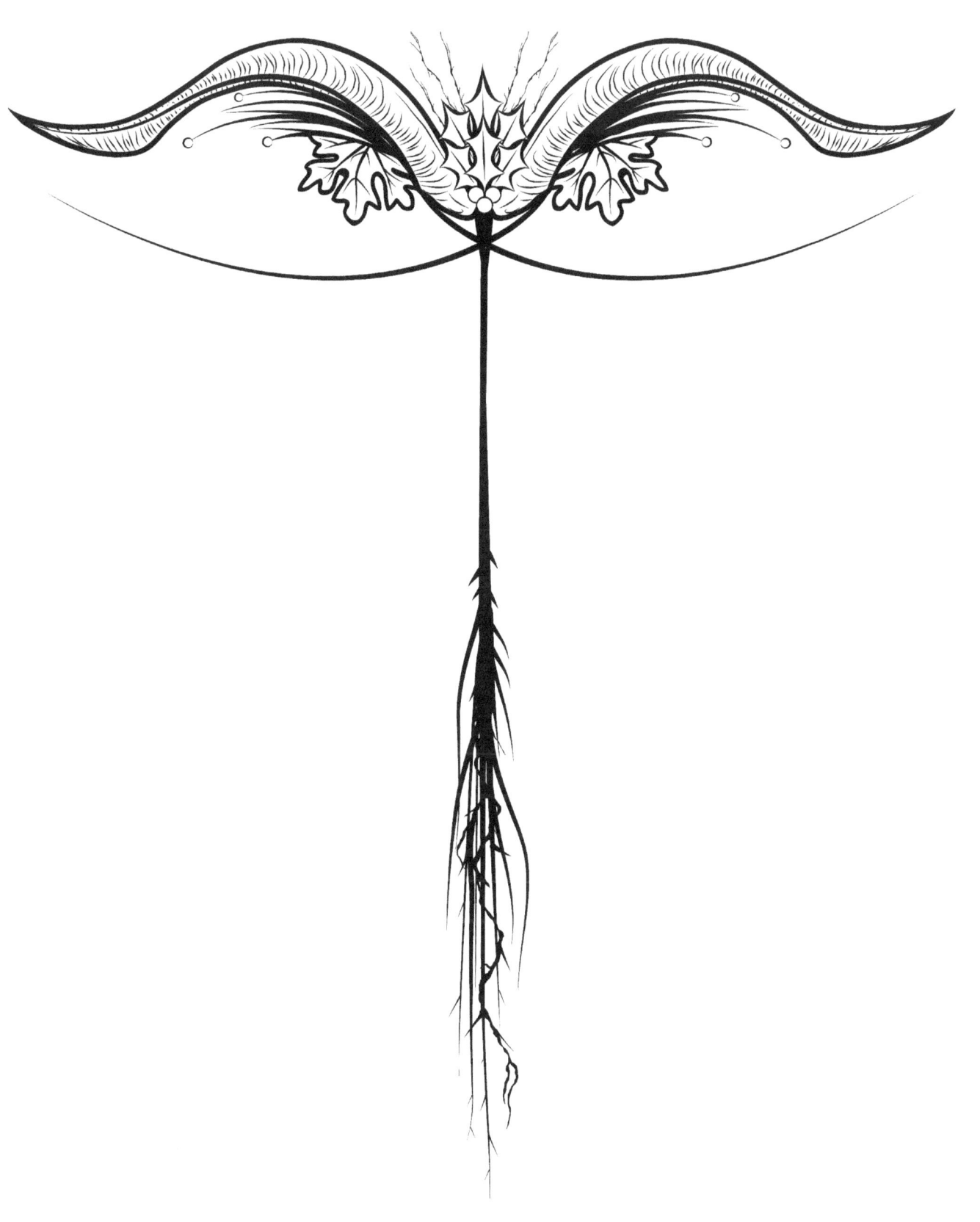

IT BEGINS

Dozing on a quiet train over the winter holidays, you idly turn your hat over and over in your hands, wondering how this time of year can be BOTH boring and stressful. Realizing that you've been in a bit of a rut lately, you consider that it's time for more adventure in your life.

Your wish is soon fulfilled. Passing through a tunnel, there's a tremendous shrieking of brakes as the train grinds to a stop. The lights go out. You wait for awhile in the empty car and then, tired of sitting in the chilling train, you step to the door of the train and descend the steps.

You realize that it was late afternoon only moments ago, but now on this side of the tunnel, it is a full moon night. There is snow thick on the ground, and the blue light makes everything look magical, with icing on the pines. The train suddenly lurches, and you stumble off the step into the crisp snow below. When you turn to clamber up the stairs, the train is just...gone.

Stunned, you turn again to face the empty white field, and then you see it.

Just a few strides away, silhouetted against the snow amongst the trees, is a scary figure, far too tall and shaggy to be human. You gasp as it lopes towards you, leaving no mark on the snow. As it lands on hooved feet just in front of you, you realise the creature is covered in rugged black fur, and has tremendous horns. It is definitely male. You can see his long pointed wolf-like ears and whip-like tail framed against the snow as his eyes glow faintly in the shadows. He holds a staff of twigs in one clawed hand and brandishes it at you. A long dark tongue lolls out of a toothy mouth.

"I am Krampus," he says, "I know who YOU are. But - have you been Naughty...or Nice?" And you realize that it's not English he's speaking and that you understand him anyway. He stares at you with huge red eyes, compelling you to answer.

"What?" You think...

If you choose Naughty go to Plate II,
and if you choose Nice, turn to Plate III.

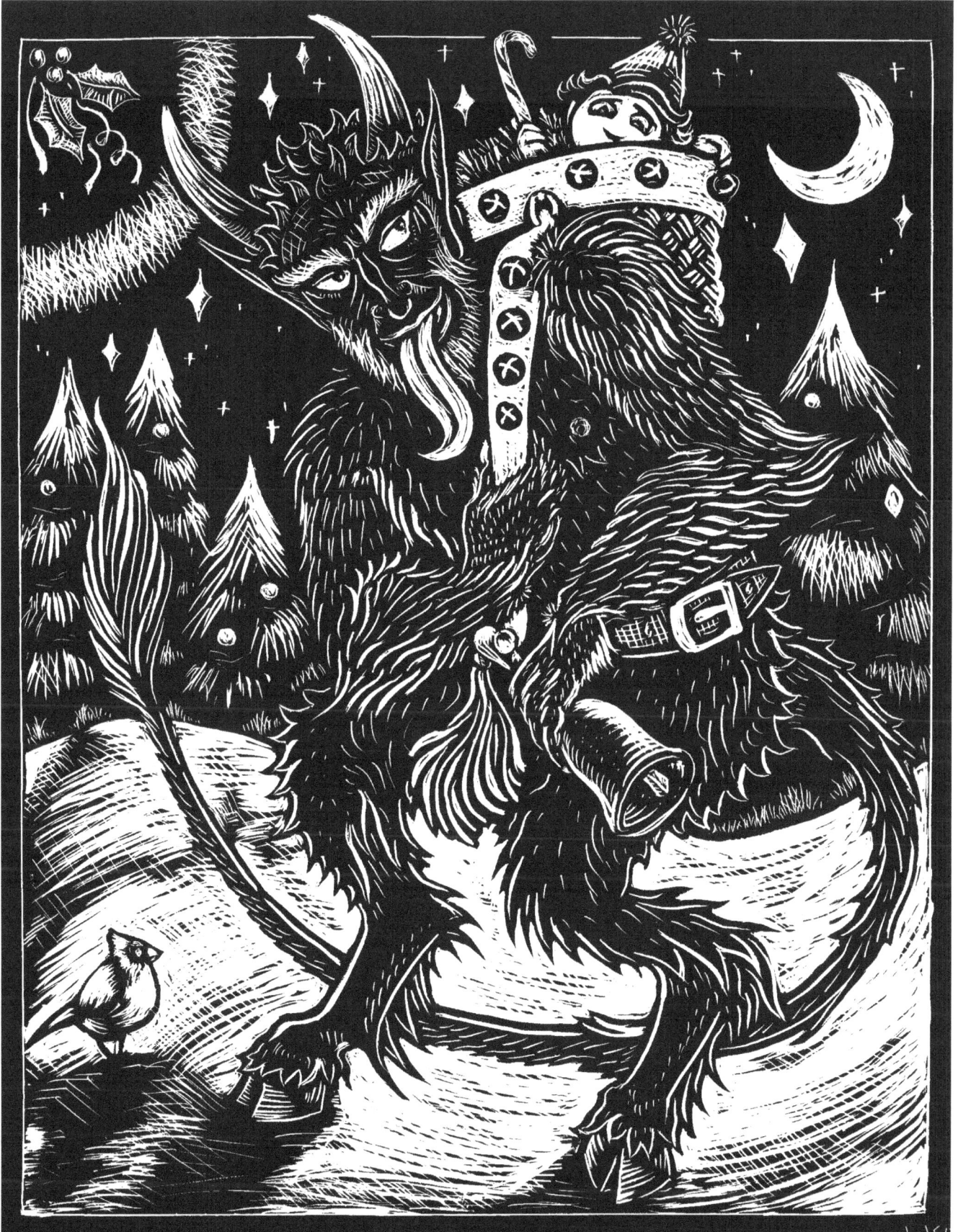

PLATE I

Naughty?" you mumble, confused by everything that's happening. He grins a sideways grin, and grabs you by the wrist with hot talons. He leaps up, and before you know it, there's a tug and a rush of crisp air, and you land on some sort of cobbled street.

Regaining your balance, you look around and realize that you have been transported to a village. There are icy mountains looming over the town and everything appears to be made of 500 year-old gingerbread. The road is lined with people of all ages in heavy clothes with lanterns. Everyone looks excited and festive. "Gross Von Krampus!" they yell, and quaff from mugs being passed around. Before you can get your bearings, the crowd surges your way. You realize they are looking up the street, past you. It is a shock to see that the great monster that brought you here is swinging his big switch and striding your way, followed by a dozen more just like him. All are clanging bells and swinging brooms and bundles of sticks. Some have big baskets on their backs. There are female creatures with antlers and staffs and tattered lace and frightening masks. There are also costumed angels and a bearded man in white you recognize as some sort of good guy St. Nick type. "Santa used to look a lot cooler in the old days," you think.

Afraid of the horde of oncoming monsters, you turn to run, but the crowd bogs you down! Terrified of being caught again, you know that at any moment you will feel those devilish claws scooping you up. Then you realize the whole crowd is laughing, jumping away from the cavalcade of horned figures to avoid being swatted with bristles. Turning, you see the crowd holding up little kids to see the monsters and steins to toast them as they thunder by. You are so confused. "Is this a game, or a hunt? How did I get here? What's going to happen?"

You look around wildly for a way out. As the road opens out into the square a pub door swings open, revealing a busy biergarten full of people. You could hide in the crowd and blend in! Or perhaps you could bury yourself in the back of this...cart? The mob surges closer.

Do you choose to go to the pub? Go to Plate V.
If you choose to hide in the cart, go to Plate VI.

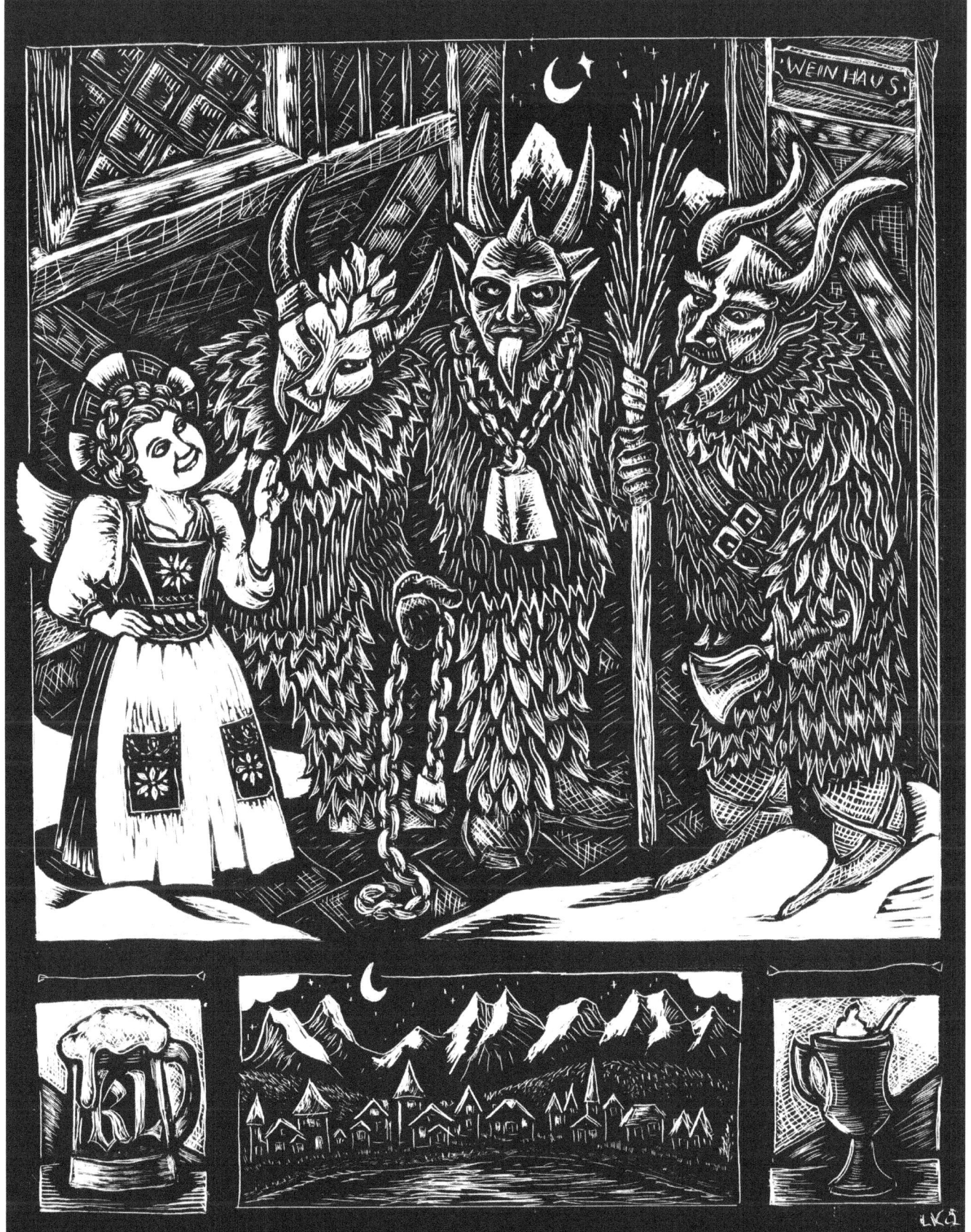

PLATE II

N-n-nice!", you stammer. Bushy eyebrows raised, he stares at you, causing you to doubt yourself. "I didn't actually want adventure", you think. "What happened to the train? Am I out of my mind?" After a long awkward pause, he plucks you up by the belt and leaps impossibly high into the freezing air. The stars blur as he drags you upwards. Moments later you land somewhere, hard. Krampus keeps you from falling with a giant uplifted hand and then strides away.

Befuddled by the sudden change, you take in the surroundings. A city street, bright lights, tall buildings, parked cars and a milling mass of people in costumes in the road meet your stunned eyes. Amazingly, this crowd is dressed up as great hairy horned Krampuses and other magical monsters. Vaguely terrified, you wonder what the plural of Krampus is. Krampi? Krampussesses? There are hundreds of them. Spiked with horns and teeth, they look menacing, but you also see LEDs and hula hoops and sparklers on display. This is a party!

The sidewalks are packed with regular folk, laughing and taking pictures. A little kid dressed as a fuzzy white monster offers you a candy cane, then growls at you and snatches it back before scampering ahead. Teenagers come by cheerfully singing, "He comes to us, straight outta the Alps, to bring his Yuletide Fright..."

You see the real Krampus start moving up the street, and the costume monsters begin parading too. A din of clanging bells and clanking chains washes over you. Unseen by all but you, he leads the crowd. Everywhere he goes, people drink more, laugh harder, hug their babies closer, leap more fiercely in their devilish play. They mimic spanking each other with brooms and sticks, and you also spy St. Nick, an elegant man in a long white robe with a group of little kids dressed up as tinsel-haloed angels. Krampus keeps pace with him, nodding and smirking.

The loud foot parade tumbles past the doors of a small shabby church. The left hand door is ajar, beckoning you to escape to the quiet. It's been unexpectedly enjoyable, parading with these party monsters. But suddenly you remember that you were on a train on your own business far away just an hour ago.

Do you slip inside the chapel to escape Krampus and his band of merrymakers? Go to Plate VII.
Do you stay with the party? Go to Plate IV.

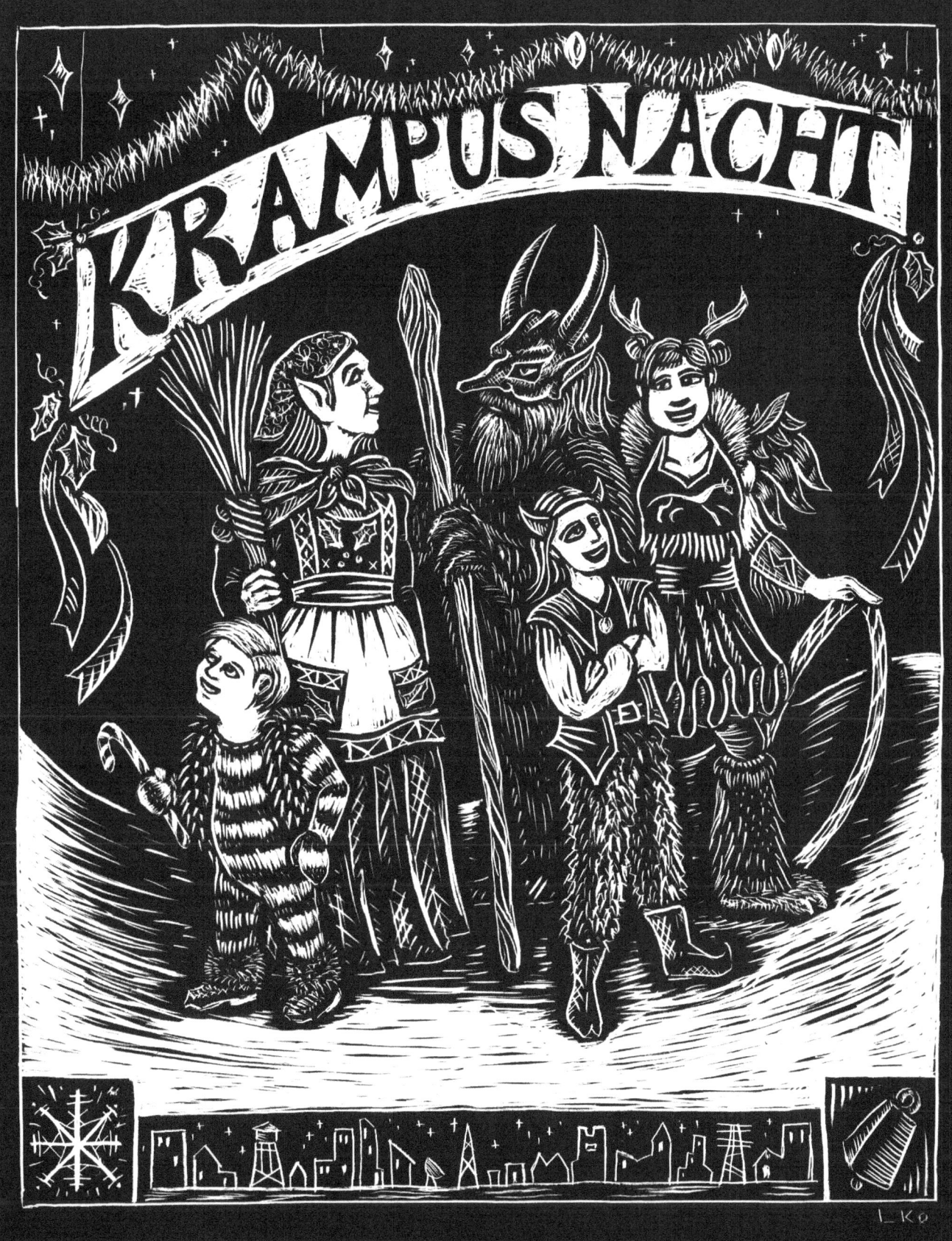

PLATE III

Krampus got you here, so you decide that he is probably the only force capable of returning you to your origin. At the edge of town, raucous partiers move the festivities indoors, carrying their pink-cheeked babies and tipsy companions into warm homes hung with ivy. Krampus appears before you, his eyes aflame. "It is time you understand even more!"

Suddenly pinching you by the heels, he hoists you into an endless blizzard. You see the snow but feel no cold as you cartwheel end over end through a billion identical snowflakes. You brace for an impact but instead loft gently down into drifting snow and silvery mist. Krampus lands smoothly beside you, and the snow melts away from his great steaming hooves.

"Wh-wh-what am I supposed to understand?" you ask, as he seems to swell in size beside you. Now he is like a vast black stag as big as a tree; a corona of brilliant stars stream out from behind his giant shaggy head, illuminating the great rack of horns.

He stamps his great foot down, and amazed, you watch a tree sprout up in his hoofprint. The saplings writhes like a thing alive, then sprouts holly leaves and blood red berries. Suddenly bursting into flame, it just as quickly dies down into black char that evaporates before hitting the melting snow.

You know in your bones why young religions feared this vision of primal splendor and danger, life and death. Amongst his vast rack of antlers you see a hundred little lambs cavorting with that sprightly joy that is the special preserve of innocence. Melting snow around his feet erupts into crocuses and then into bushes ripe with fat berries. Krampus laughs, leaning down and taking you in hand. He closes those enormous claws around you and when he opens them again, you are high in the air over blue sparkling waters.

Surprised by the soaring view, you overbalance and are nearly carried away by the lively winds. Do you jump for it, knowing that in this mystical place you will be protected, or do you burrow down in the Wild Man's hand for a safe journey?

If you jump, turn to Plate VIII, and if you wait to see what comes next, turn to Plate X.

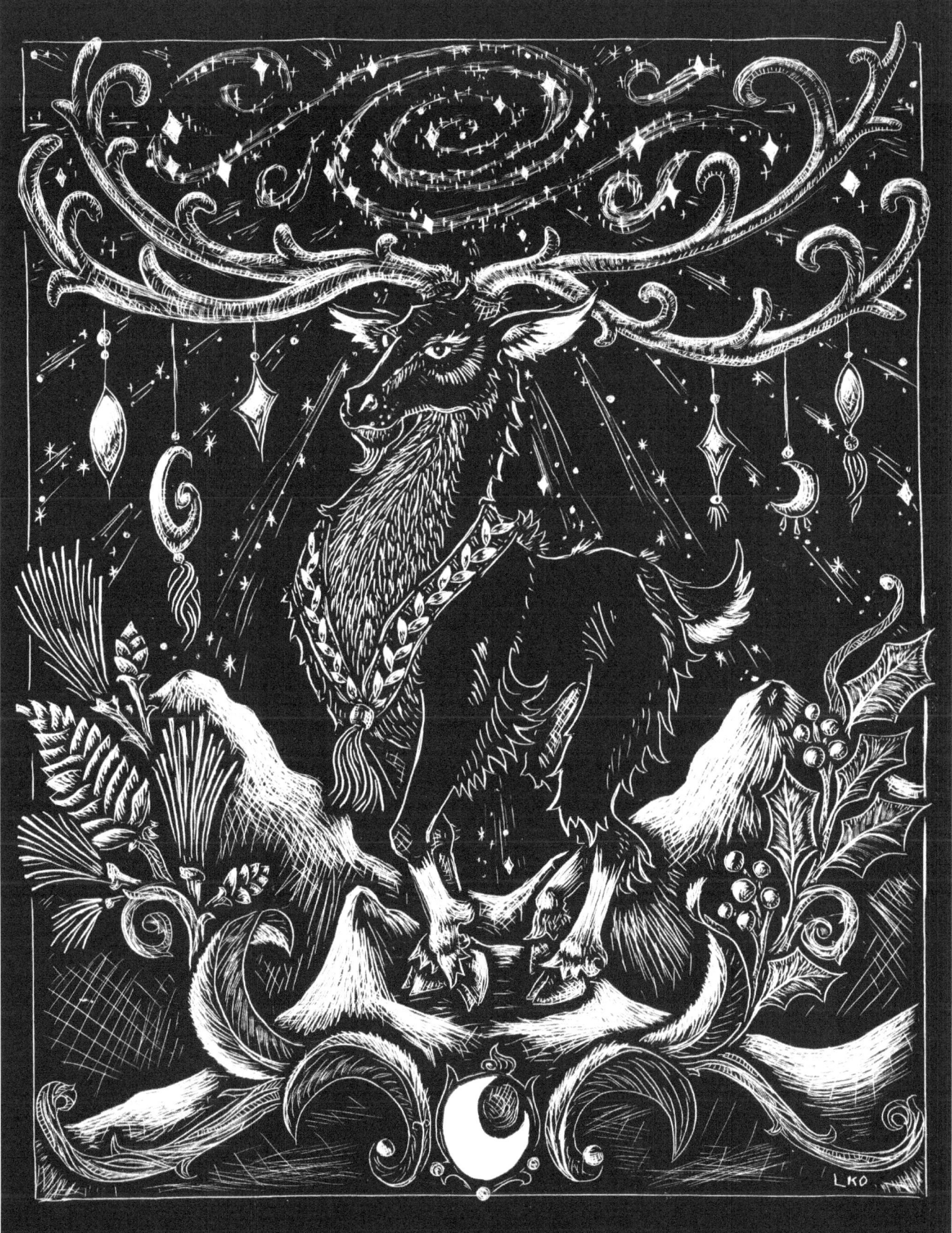

PLATE IV

Ducking low, you press into the crowd hoping to blend in. Indeed, no one seems to notice you, even though your pounding heart seems so loud! It was many hours ago that you ate a slightly soggy sandwich on the train, and you consider ordering food at the counter. Everyone is in a festive mood, slapping each other on the backs. The sheer volume of sausage, beer and schnapps being served suggest that this event is somehow German. Is your money even any good here? Backing into a corner whereby can keep an eye on the door, you try once again to understand how you ever found yourself here.

But in a moment, there is an incredible noise in the street like a helicopter. It seems so alien amid this timeless festivity. The place empties out as everyone rushes to see what has just arrived. Curiosity drives you to the door with the last of the crowd. You find yourself abruptly elbowed to the front row of spectators. There on the curb is a great red motorcycle with a sidecar, revving its engine and playing to the crowd. It is shiny with chrome, and astride it sits Krampus in goggles and a huge duster coat. His tail is curled around one arm to keep it clear of the wheels, and he is grinning with a huge toothy smile. In the sidecar sits St. Nick with a great scarf wrapped around him and his bishop's hat held tightly.

Two burly woman dressed as angels soon help the Saint out of the sidecar and gesture you in his place. Stunned, you are bundled into the little metal pod as they cram onto your head a big black helmet decorated with flames! The last thing you see is everyone cheering as the engine screams and Krampus roars.

The village falls behind as the beast tears across the countryside, finding smooth passage even where the roads look rutted. A full moon blazes overhead and you are grateful for a helmet in the cold. Krampus slows as the road comes to a fork. A sign points in either direction but the script is so weathered, there is no deciphering it. To the left, the road goes steeply downhill into mist, and to the right it opens out over a snowy plain. Your gigantic pilot turns to you, pantomiming that he wants YOU to pick the direction.

<center>If you pick left turn to Plate IX.
If you choose right, turn to Plate X.</center>

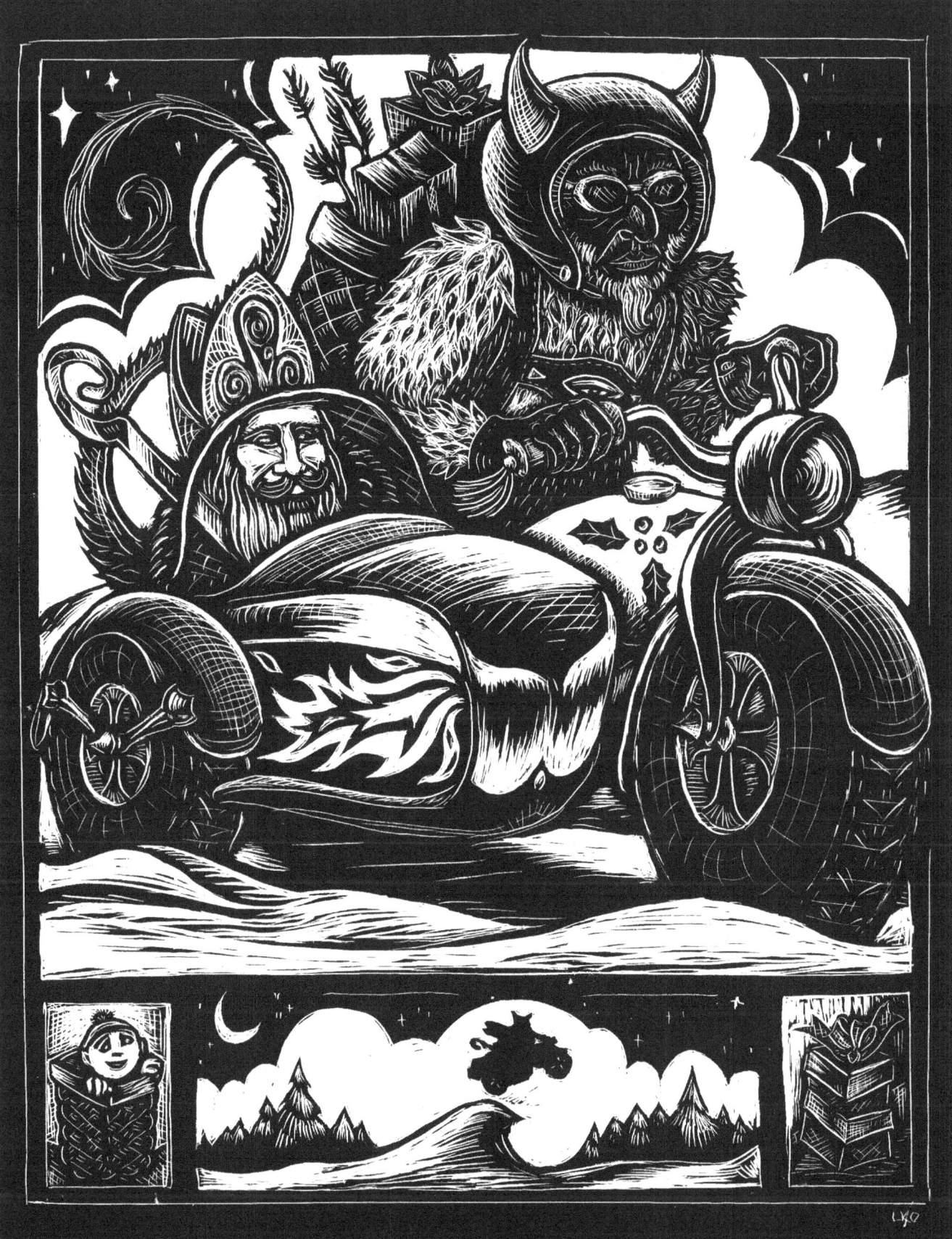

PLATE V

Scrambling in and burrowing down, you pull some sacking and stray straw over yourself and try to look inconspicuous. It is cold; you are surprised that you are not freezing. Revelers stream by on either side, laughing loudly and bumping into the cart till the street grows nearly quiet.

Just as you are ready to leap from cover, a sharp clopping sound and sudden heavy silence tells you that Krampus is back. You hold your breath.

With a sudden movement he lifts the sacking off of you, revealing your hiding place in the straw. He's carrying a big woven basket on his back ringed in bells and he swings it down. With a grim smile, he stuffs you in the basket; it's bigger on the inside, of course, and already full of people!

"What're YOU in for?" asks a squirrelly-looking kid with freckles. "Me, I kicked the cat." A long- haired kid chimes in, "I sucked my thumb - just for spite!" The third inmate volunteers pridefully, "I threw away all the paper in the public bathroom stalls, for fun. I'm pretty bad."

"Uh..." you mutter, "I told him I was Naughty..."

"Oooh," the bad kids recoil and start whining. Everyone is anxious; conversation stops as Krampus hoists the basket to his shoulders. "Where are we going?" you shout. No one says a word. Flashes of red and darkness go by in a blur as you are thoroughly jostled for what seems like hours. Eventually the basket is set down in the snow. Pushing aside the sacking, you peer out at a snowy landscape ringed with hills and holly. You contemplate an escape into the unknown. Some of the kids run through the crusty snow, some cower in the back of the basket, afraid to compound the trouble they are already in.

If you dare to sneak away, turn to Plate IX,
and if you wait with the other delinquents for Krampus to deliver you to your fate,
turn to Plate VIII.

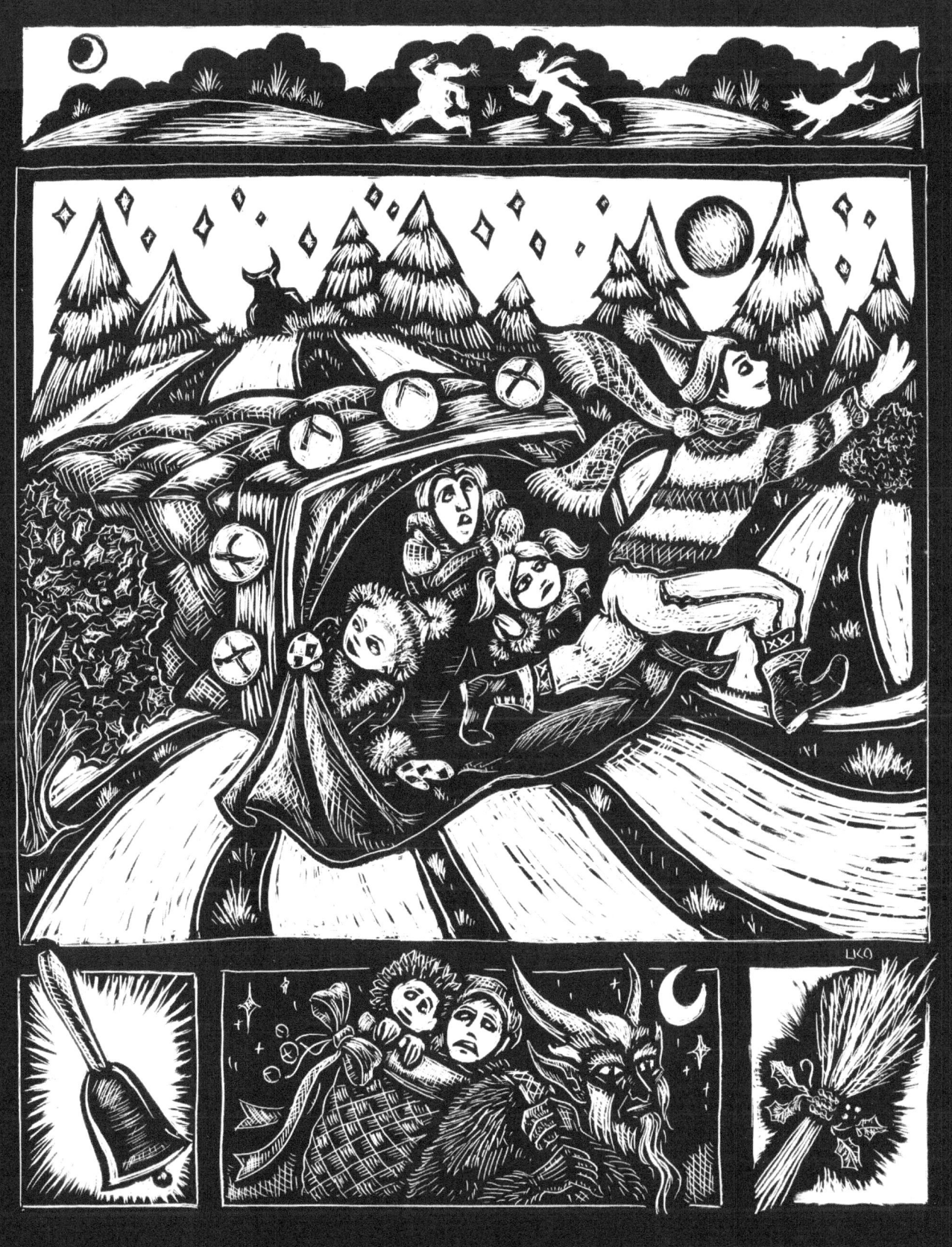

PLATE VI

Stealthily you slip into the chapel, thinking that nothing with big horns would dare to follow you in here. A few candles glimmer in the darkness. You breathe a sigh of relief and cross the dark floor to look up at the moonlit pictures in the windows.

Sensing someone behind you, you turn and see St. Nick, flanked by angels, coming along the aisle. They circle you at the foot of the altar, St. Nick in a long white and gold robe embroidered with greenery. His long beard reaches his middle and on his head he wears a tall hat ringed in ivy. Something about his wise, kind face makes you realise that this is the real Saint, not another tipsy reveler in a bathrobe.

"You have had an adventure, and now you have questions." He says kindly. "Yes!" You realise that you DO have questions. "What is this all about, what is the secret of Krampus? I thought this time of year was all about peace, and presents! Why do you allow this scary monster to happen to the holidays? He's terrible!"

St. Nick smiles. "You mean that he is Awesome, in the ancient sense! Inspiring Awe. Life demands balance. In the dark times of human's winter, I get the good part, he gets the hard part. Feast and Famine. We complete each other. And there can be no spring flowers without the compost of the previous year. And sometimes, yes, he can be too fierce, too scary, too punitive. And yet is not modern Christmas too plastic, too saccharine, and too commercial? Together, Krampus and I work to keep it real. Do good unto others, or else."

Walking with you around the church, he shows you that all among the saints and angels are many gargoyles and other creatures with horns and hooves and crowns of ivy. "We have always worked together!"

It's a lot to think about. After St. Nick and the angels leave, you sit awhile watching the candles burn. Finding some money in your pockets, you leave some in the donation box and light one yourself. Heading to the door, you look back at the calm, vaulted space, like a forest made of stone and stained glass, then step outside.

At first you close the church's door behind you, but decide to leave it open just a crack as you step through. Turn to Plate XI.

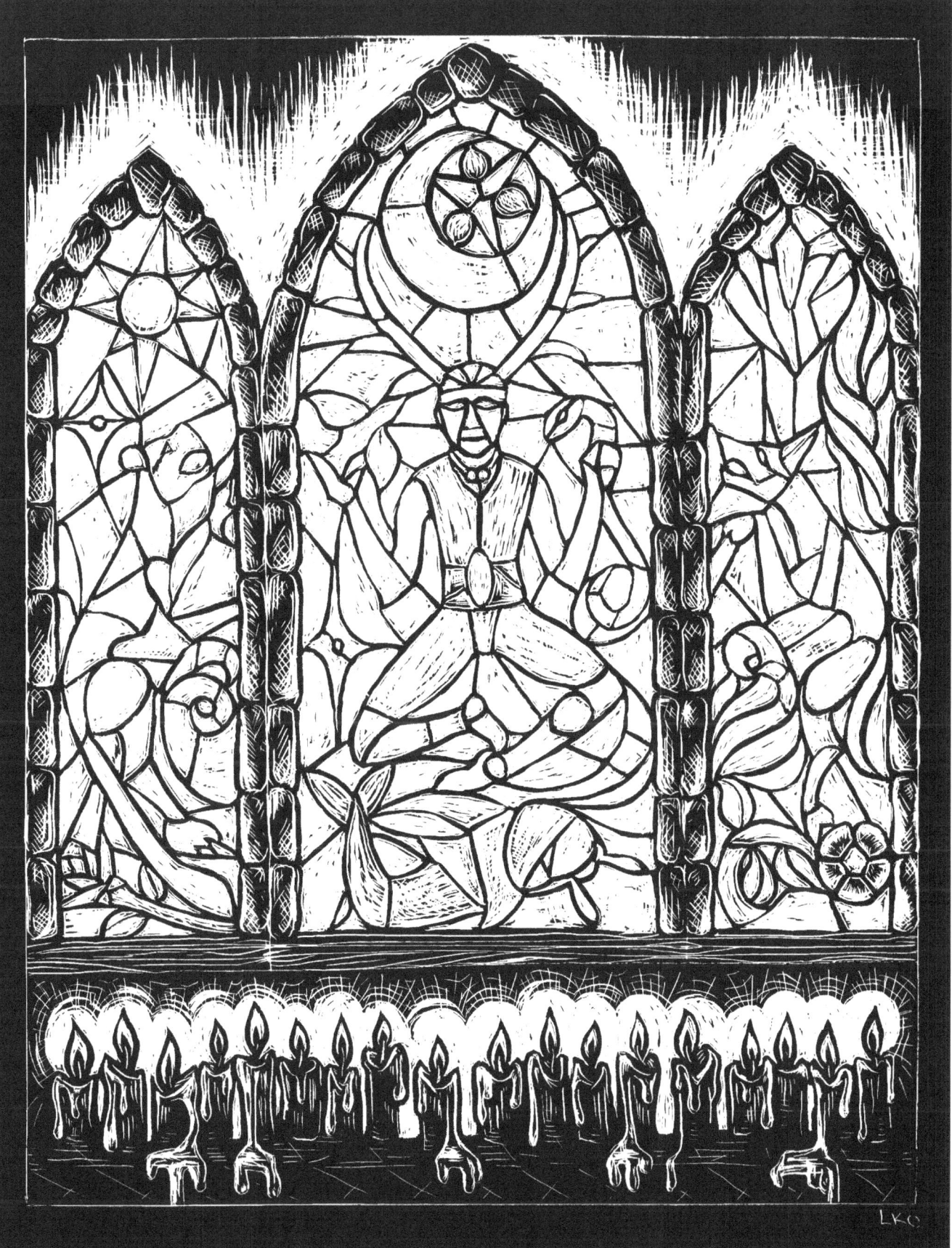

PLATE VII

Tumbling forward, you find yourself magically in a sparkling wonderland. This is clearly not a place on the map, but the North Pole of faerie tales. One sure giveaway is the candy-striped signpost marked 'North Pole'.

Brightly colored people of all species are skating, sledding and building in the snow all the way to the treeline. Lush conifers with boughs laden with shortbread and popcorn are full of bright blue and red birds. Giant elk with their majestic horns surmounted by great candles move gracefully through the landscape, bowing their heads to accommodate the occasional toaster of marshmallows. Squirrels in tiny sweaters chase each other up and down the snow banks and red pandas throw snowballs at passers by.

Krampus is nowhere to be seen, and just when you aren't sure what to think or do, a great woman with an enormous broom and embroidered apron appears, waggling her long pointed ears at you. "Scruffy," she says disapprovingly, brushing straw and fur off of your shoulders. One of her feet is webbed like a swan. Catching your eye, she smiles a sweet catlike smile that hints of sharp teeth and she guides you toward a cabin in the trees. "I am Perchta, changeling Goddess of the forest. What you came for," she says, pointing with her broom, "is in there."

As she moves limping back over the snow, a nearby badger says, "Mind your muddy feet in there. Perchta is big on tidiness. REALLY big." Acting as if you take advice from talking animals every day, you glance back at the idyllic forest and fields of playful creatures. This is the least diabolical thing you've seen all day.

Turning to step through the cabin's candy-cane door, you are very surprised by what you see. Turn to Plate XI.

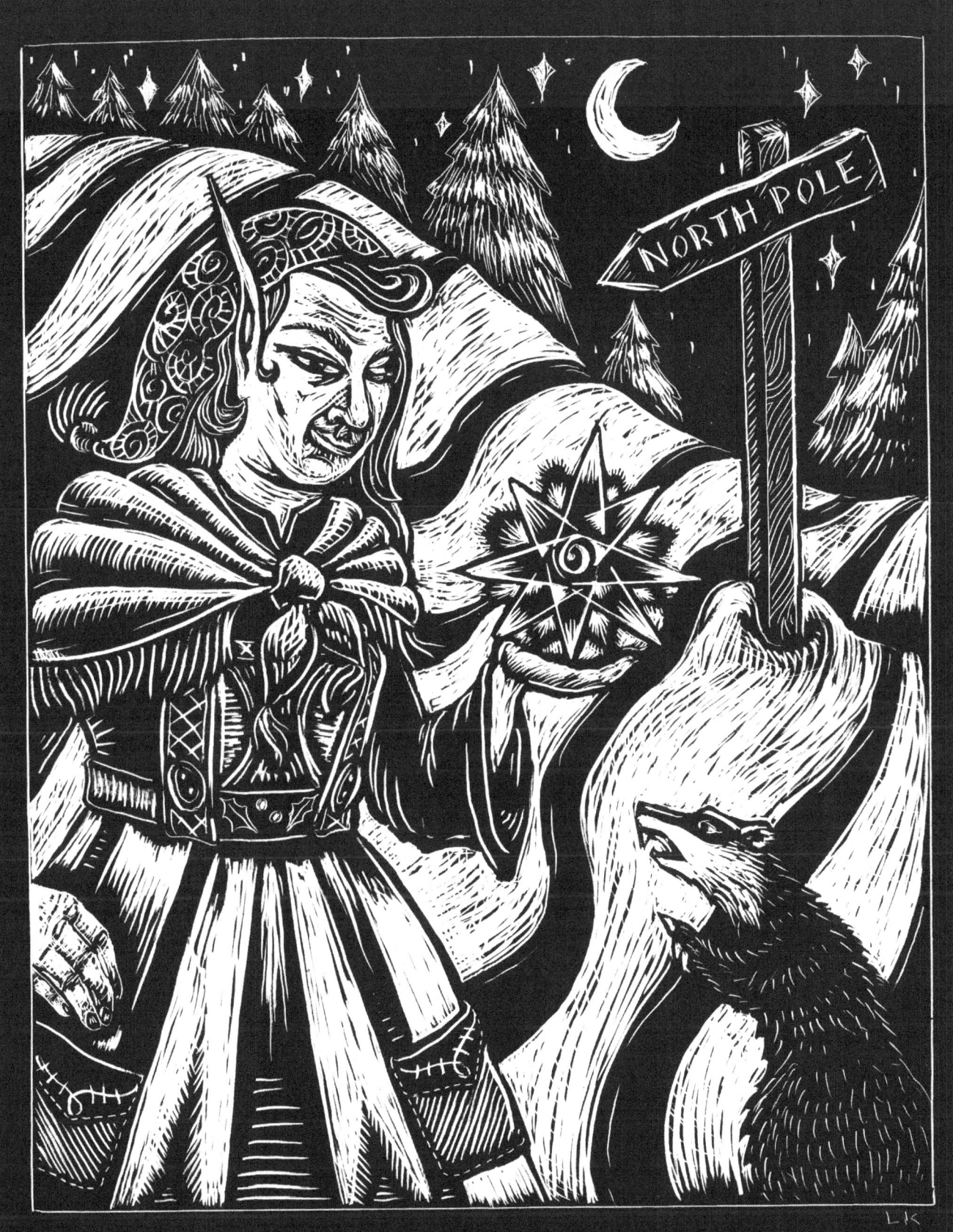

PLATE VIII

Suddenly you are mysteriously on your own, feeling nervous and vulnerable out in the mist. The path descends steeply, and you soon begin to question your decision to come here, and indeed to pursue adventure at all. The landscape is starkly barren and menacing here, and upon arriving at a big stone gate, you hurriedly approach and enter.

The first thing you notice is the heat, which goes from welcome respite from the cold to overwhelming. There's a vast river of fire full of enormous glowing lizard creatures, and between that and the Runic signpost saying 'Hel', you're pretty certain where you've ended up.

As you veer away from the ever-burning flames, the unmistakable silhouette of Krampus looms ahead, exulting in the heat with his arms raised. "Here!" He calls. "When you spent so many centuries being cold, the heat warms the bones. Now come!" he laughs. What else can you do? Following him closely, you try to imagine a way out of this awful place.

Unsurprisingly, Hell seems to be full of people. Peering through a nearby doorway, you see what appears to be a ghastly banquet with humans and monstrous creatures dancing and fighting and feasting. You hope the meat is no one you know. There are piles of bones and refuse and rubble everywhere. The living flames ripple with figures of beasts and humans alike. This is not the party you want to spend forever at!

Standing by a door with a beaded curtain, Krampus gestures you to look closely at the beads. Each one is a tiny perfect skull! Definitely awesome, but awful. Taking your soft human hand in his claw, he slowly and deliberately scratches the back of it with his great black talon. The cut is not deep, but enough to raise a thin welt of red. He hisses, "Remember!"

The cut stings, but after the day you've had, you are mostly concerned about getting the heck out of Hell. He gestures you through the veil of skulls.

Not knowing what terrors lie ahead, you step through. Turn to Plate XI.

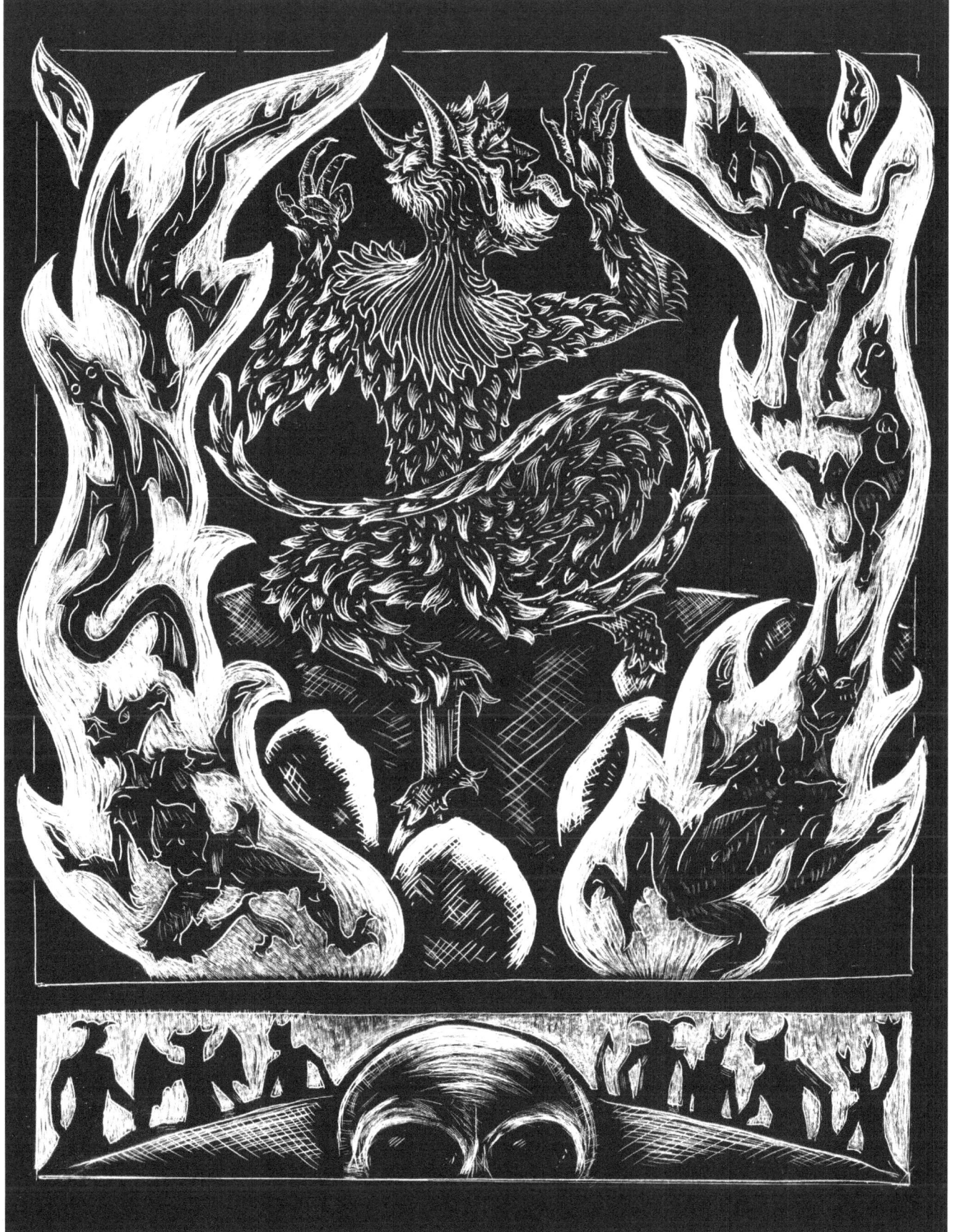

PLATE IX

With a jolt, soaring through a warm nothingness, you arrive alone on a beautiful tiled patio at mid-day. Warm, lazy sunlight blazes in your eyes like familiar but forgotten music. Pleasant fragrant breezes play through the potted plants all around you. In short, this couldn't be more different from where you just came from. There is a small circular table and chairs, set with a large pitcher and small plates of amazing-looking food. Looking out over a beautiful view of stuccoed houses and fanciful domed buildings, blue water twinkling in the distance, you can't begin to guess where you are now, or why.

A door opens behind you, and Krampus himself clatters onto the patio. How does he do it? He's more your size now, and his face, while still alien, looks relaxed. He settles down somehow in a chair and kicks back. His long hooves have been trimmed and polished, his shaggy fur is shiny and tangle-free. He pours a great goblet of something red, and leans back with a toothy smile.

"Spain." He says, "You're in Spain. All the old stories said that I carry people off to Hell... Or Spain. I think that back in the day for rural cold-weather folks it was just another word for a far away, hot place. The song even says, "...and the lucky ones go to Spain" So now, it's Hell for work, and Spain for vacation. Have some eggplant."

Tucking into the food, you decide it tastes like summertime. It is hard to imagine that this is the same scary monster that scooped you up from the field earlier today.

Satiated after a delicious meal and a crazy day's adventure, you explore the balcony, smelling flowers, enjoying the mosaics. As you open a gaily painted door off the patio, a sudden blast of cold air startles you.

Stepping into the space beyond, you are very surprised! Turn to Plate XI.

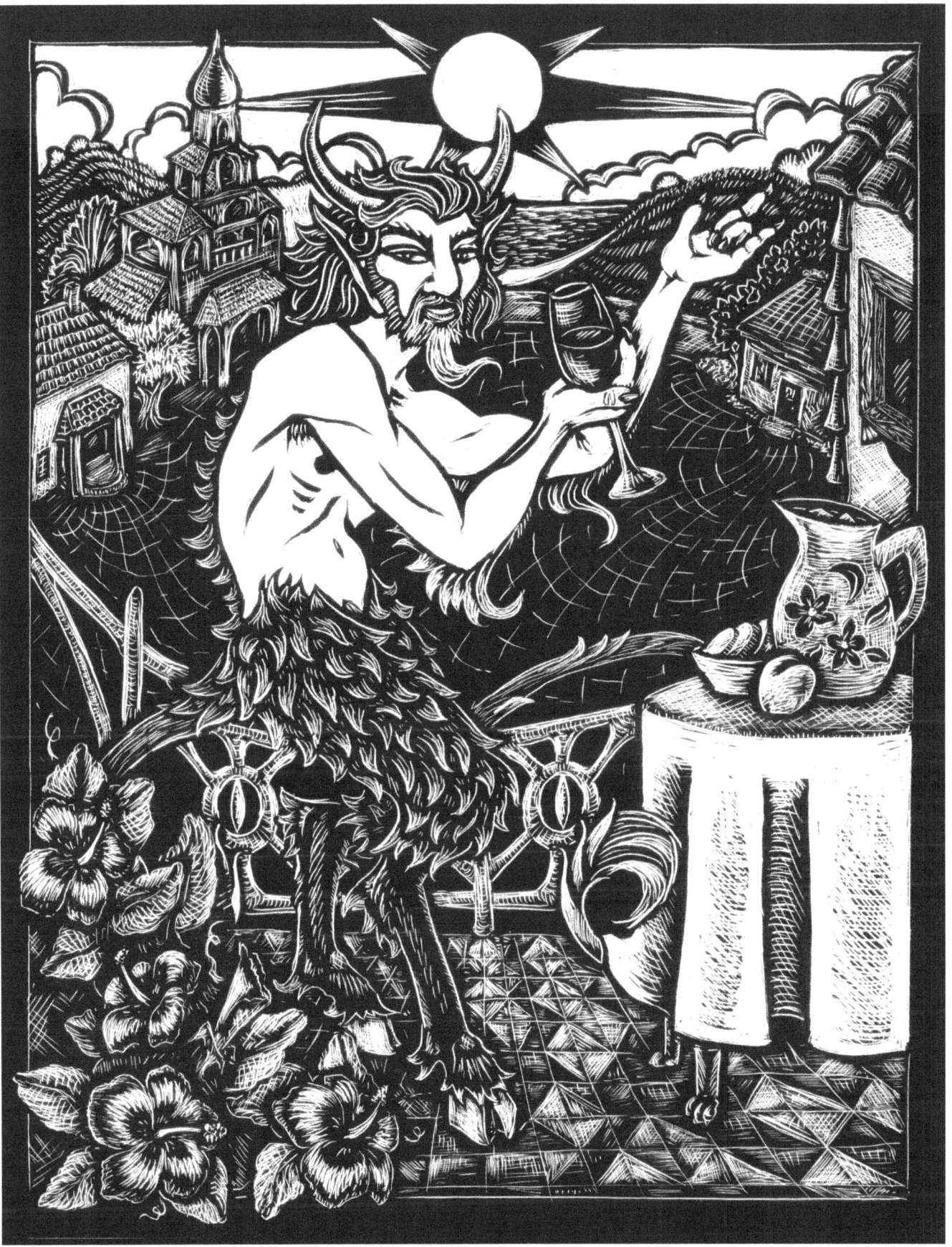

PLATE X

Amazingly, you find yourself back in your cabin on the train. The dull ride of earlier today seems so long ago! The lights stutter on and the silent train jolts to life like a great animal that has been sleeping. You realise it is once again not night, but afternoon, and the subdued winter sun is making a valiant effort, streaming in through the window. You stumble in a daze to your former seat as the car begins to fill again with other passengers. There is a mood of conviviality throughout the place and folks at one end of the cabin start warbling old folk songs. "If your kids are naughty, or you dig old time religion…" they sing.

A cart of warm rolls and tea trundles along, pushed by a familiar woman with an embroidered apron and a sly smile. She hands you a cookie and a package wrapped in string. There is a few bits of straw and familiar dark fur stuck to it, and you smile as you brush it off before opening the package. You turn to thank her, but she's already moved down the aisle. There is definitely a limp there as she goes, offering treats and fussing over your fellow passengers.

Inside the wrapping you find a handmade doll. It is shaggy and made of sheep wool with a long fluffy tail and felt horns. It is an adorable version of the terrifying creature that you encountered in so many forms on your amazing journey today. You turn it over and over, gazing at the red button eyes and shiny red ribbon tongue. Sitting back, you eat your warm roll, pleased in the knowledge that many more adventures await you in the new year.

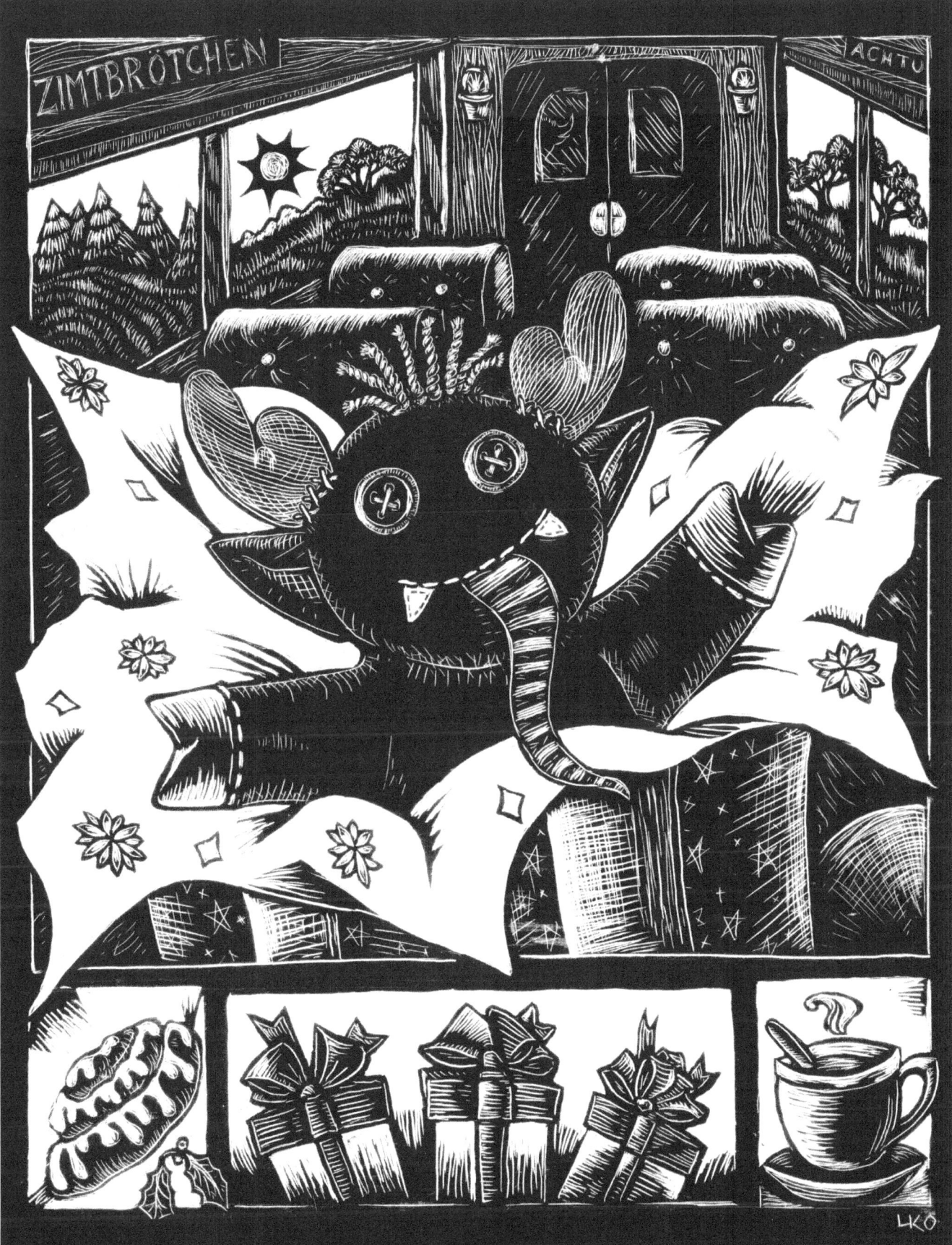

PLATE XI

A Krampus Carol
by Lauren Onca O'Leary

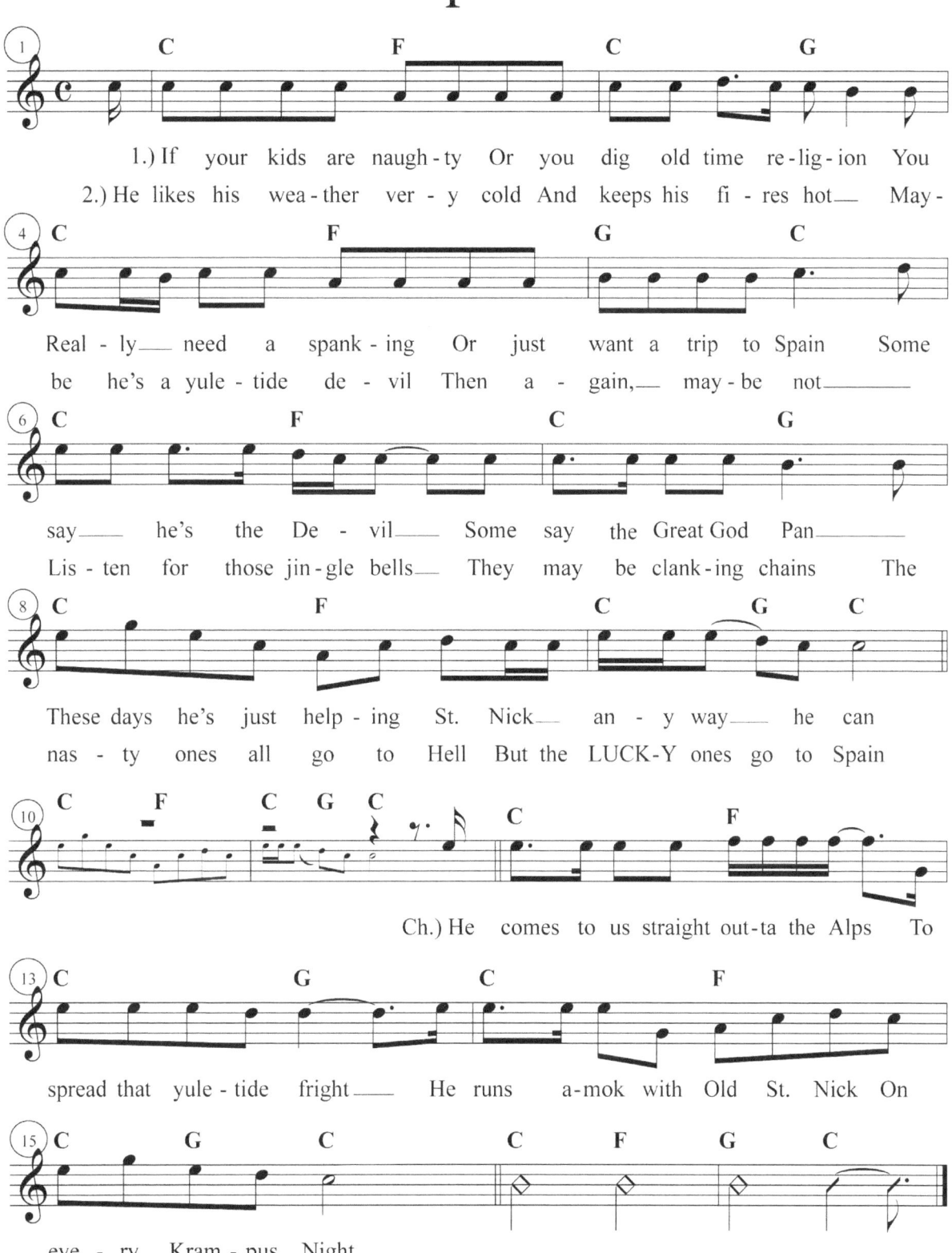

PLATE XII

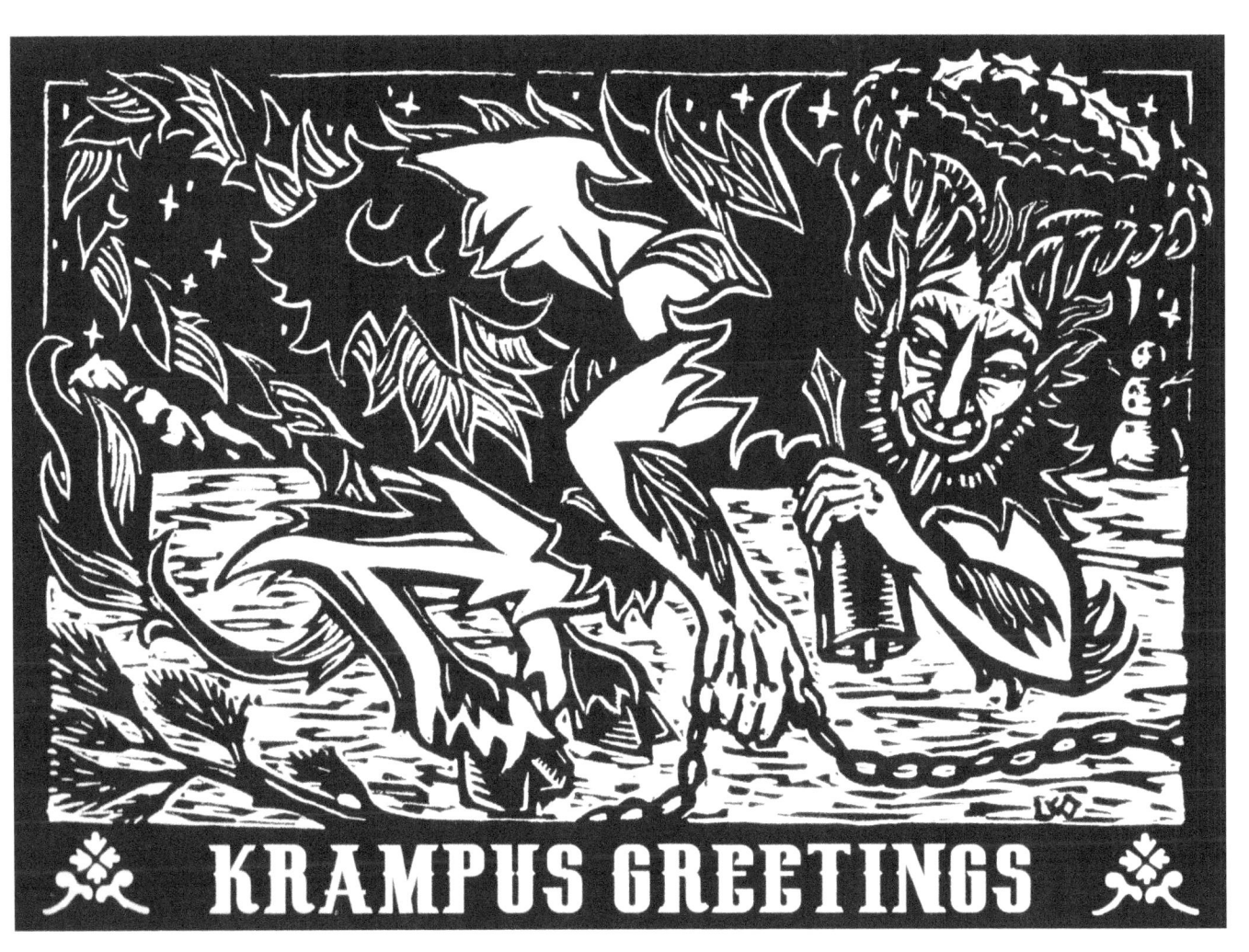

PLATE XIII

www.ingramcontent.com/pod-product-compliance
Lightning Source LLC
Chambersburg PA
CBHW080550190526
45169CB00007B/2709